ART NOUVEAU DESIGNS

39 Renderings

by

Ed Sibbett, Jr.

Dover Publications, Inc.

New York

Published in Canada by General Publishing Company,
Ltd., 30 Lesmill Road, Don Mills, Toronto, Ontario.
Published in the United Kingdom by Constable and Company, Ltd.

Art Nouveau Designs, as published by Dover Publications,
Inc., in 1985, is a slightly revised republication, incorporating
all 39 designs, of the work originally published by Dover in
1981 under the title *Art Nouveau Style Coloring Book.*

DOVER *Pictorial Archive* SERIES

Manufactured in the United States of America
Dover Publications, Inc., 31 East 2nd Street, Mineola, N.Y.
11501

Library of Congress Cataloging in Publication Data

Sibbett, Ed.
 Art nouveau designs.

 (Dover design library)
 (Dover pictorial archive series)
 Originally published: Art nouveau style coloring book.
1981.
 1. Decoration ornament—Art nouveau—Themes, motives. I. Title II. Series. III. Series: Dover pictorial archive series.
NK1380.S53 1985 745.4′441 85-10279
ISBN 0-486-24179-3

PUBLISHER'S NOTE

The term Art Nouveau was introduced by Samuel Bing in 1895 to describe decorative art objects for sale in his Paris shop. As the term implies, artists working in this style sought a "new" art form, one that was not dependent on past styles for its forms and inspiration. Of course all styles have antecedents (we can trace Art Nouveau's lineage back through the nineteenth century, specifically to the influx of Oriental art to Europe and the revival in midcentury of the applied arts and crafts), but the efforts of Art Nouveau's practitioners, Aubrey Beardsley and Alphonse Mucha among them, resulted in a distinctive, appealing style. The characteristics of this work—highly stylized floral patterns, curving lines, sensually posed women with long, wavy hair—are now familiar to us all, as Art Nouveau experiences its current resurgence of popularity, even though the "high period" of Art Nouveau ended by 1910.

The thirty-nine illustrations in this book are adaptations by artist and illustrator Ed Sibbett, Jr., of actual works in the Art Nouveau style. While maintaining the spirit and essential forms and lines of Art Nouveau, Sibbett has carefully rendered each plate with the artist, designer and craftsperson in mind. Thus *Art Nouveau Designs* serves as a readily available source of copyright-free designs for use in one's own decorative work, as well as an inexhaustible source of ideas and inspiration for all. And, for those so inclined, this collection provides a delightful coloring experience.

ART NOUVEAU DESIGNS

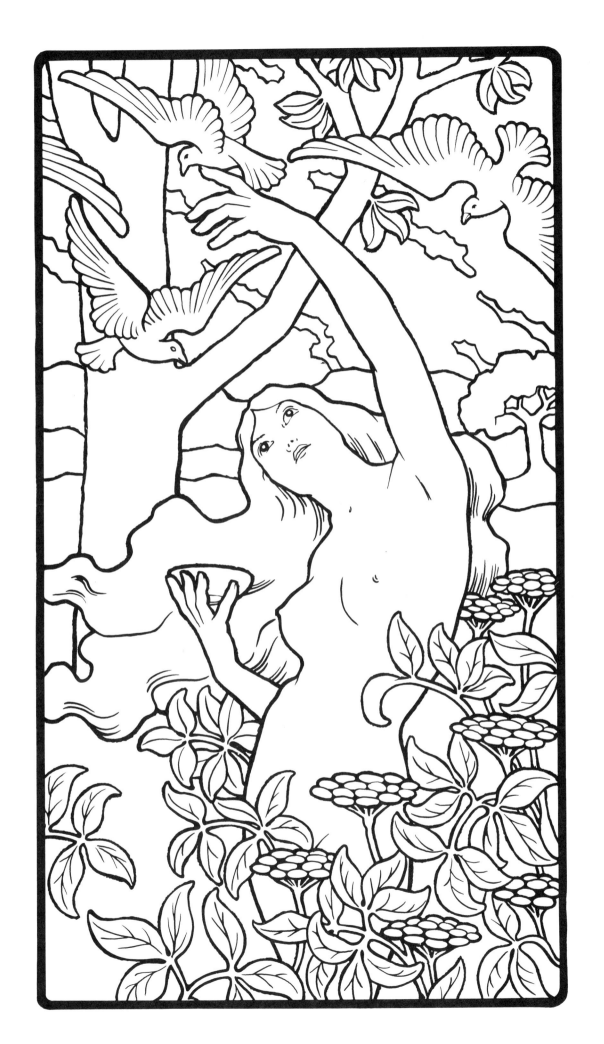

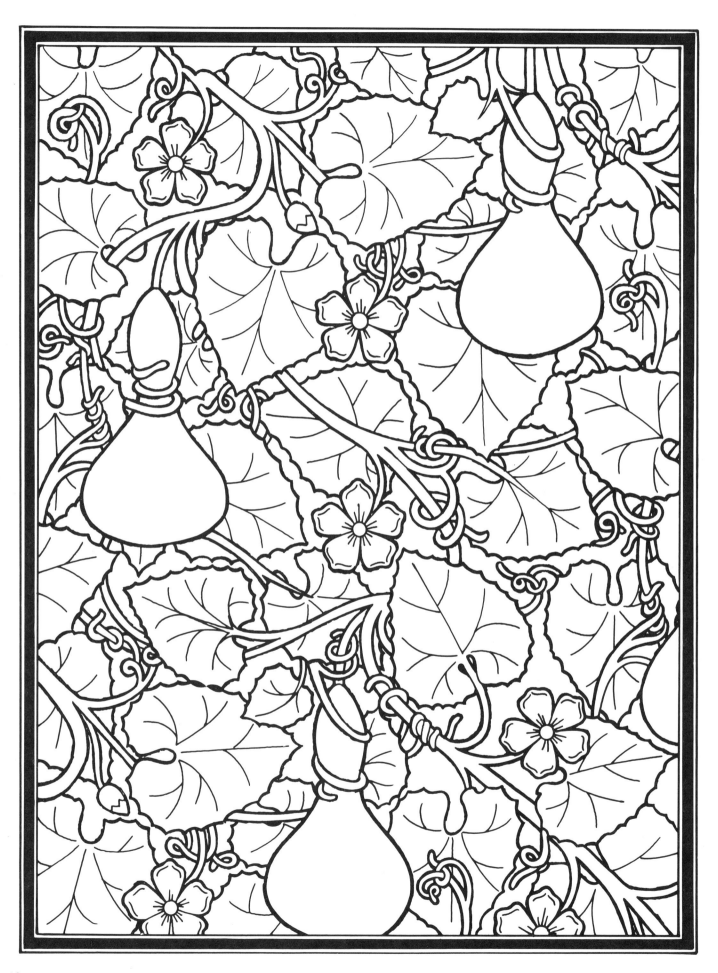

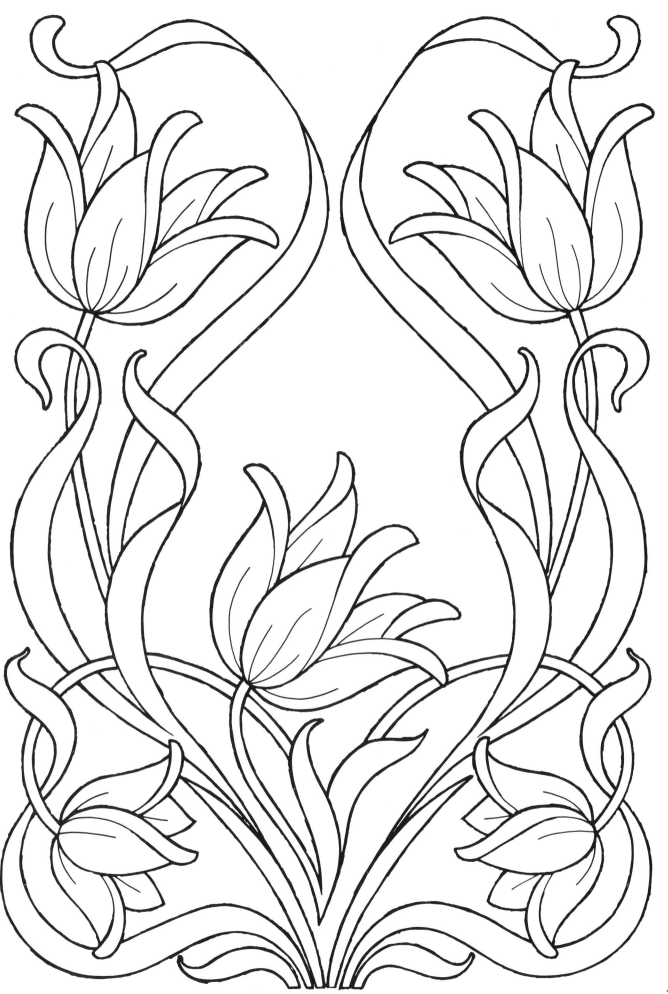

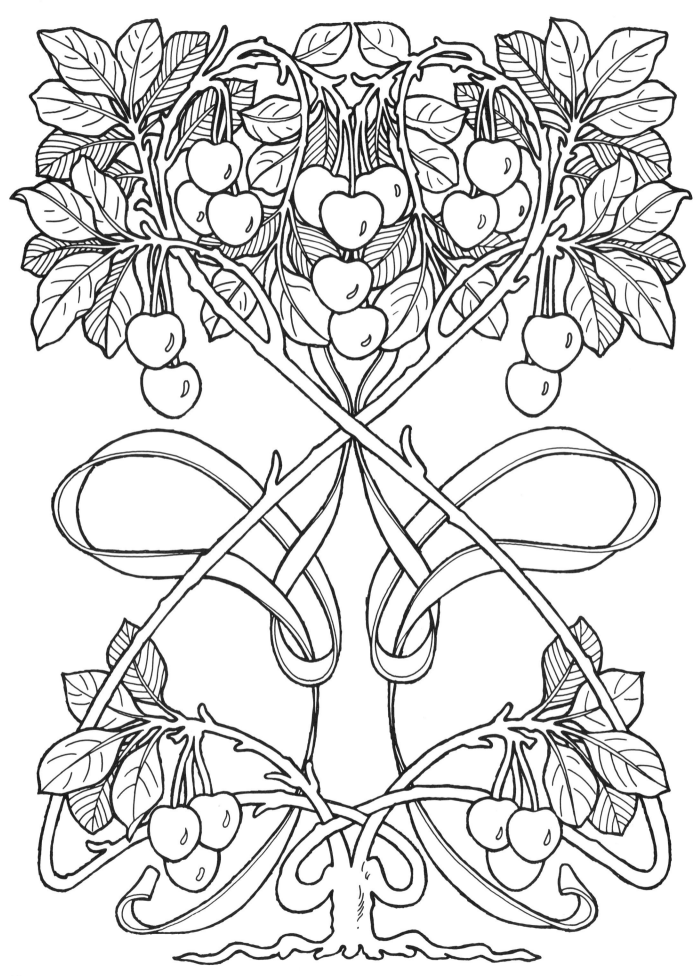

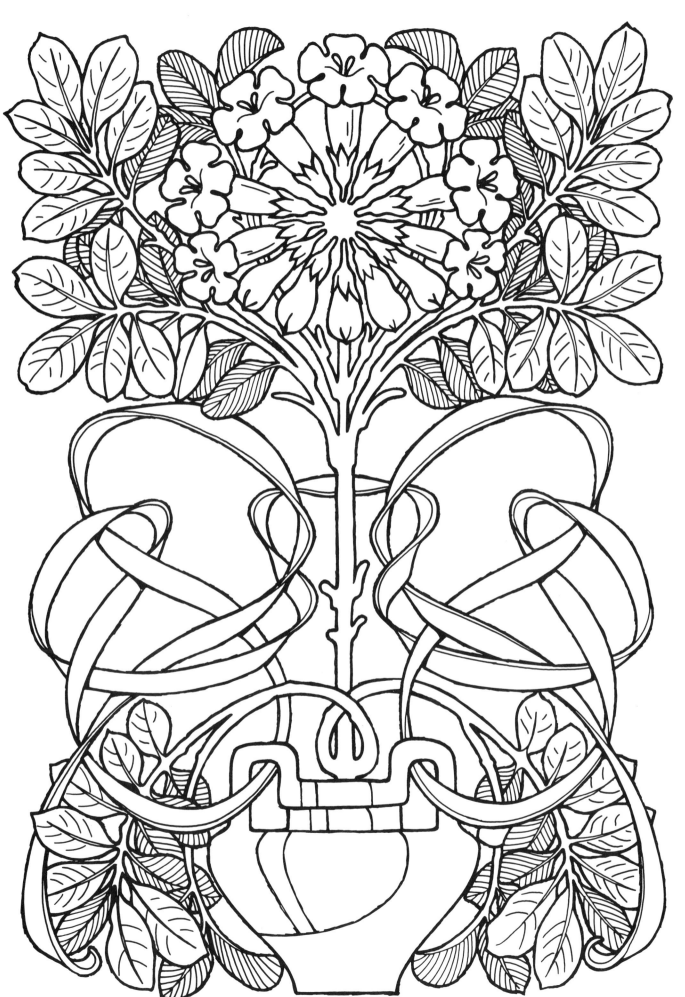

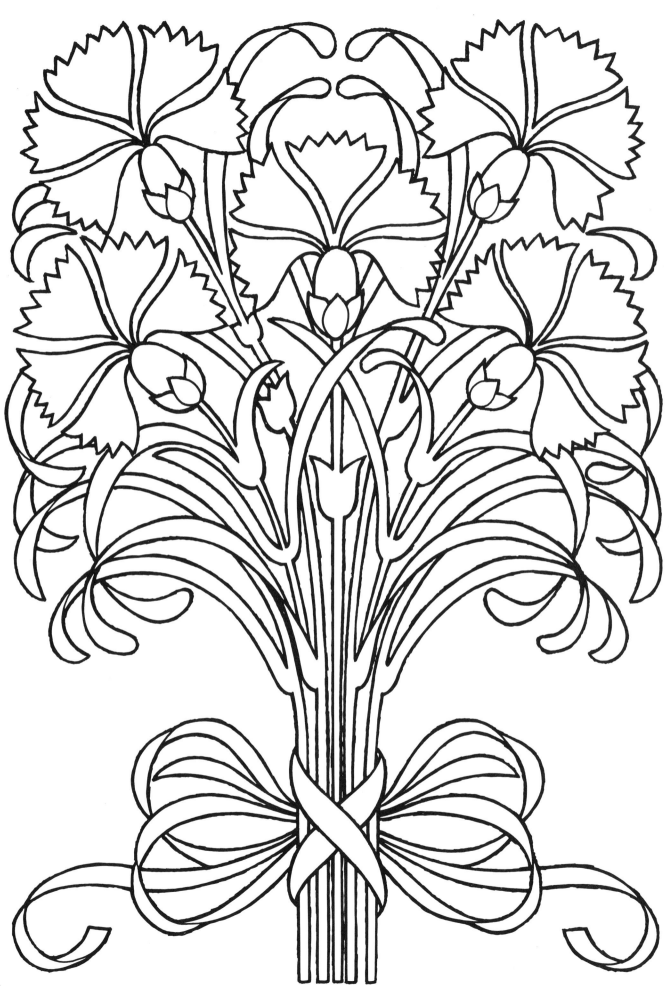

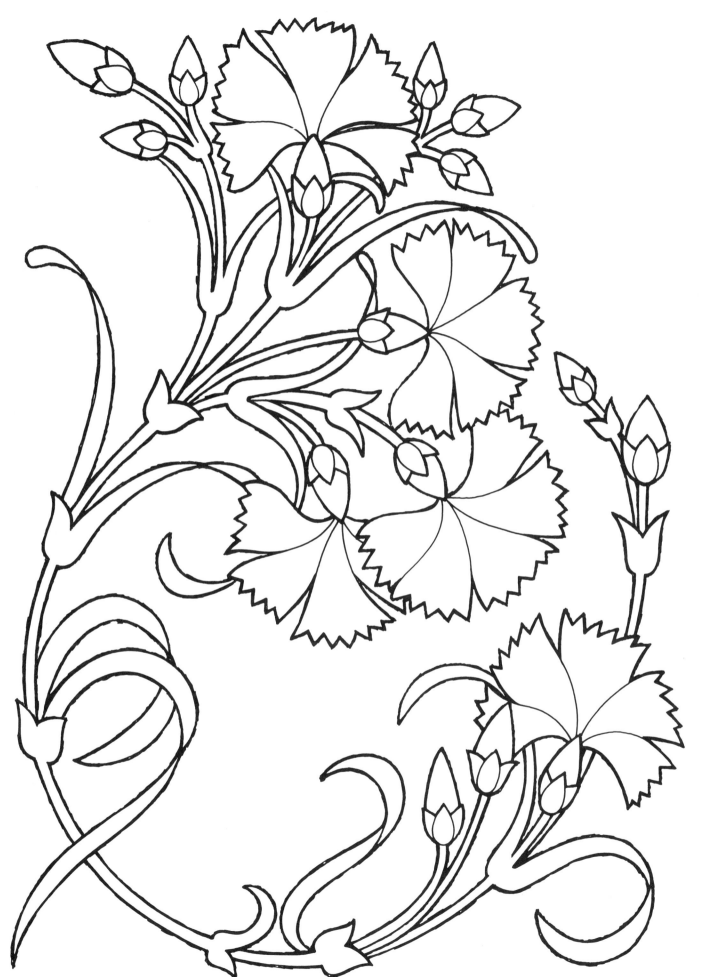

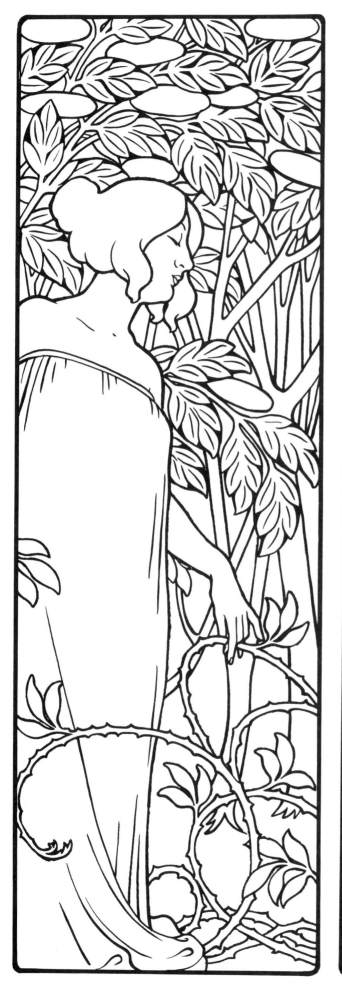
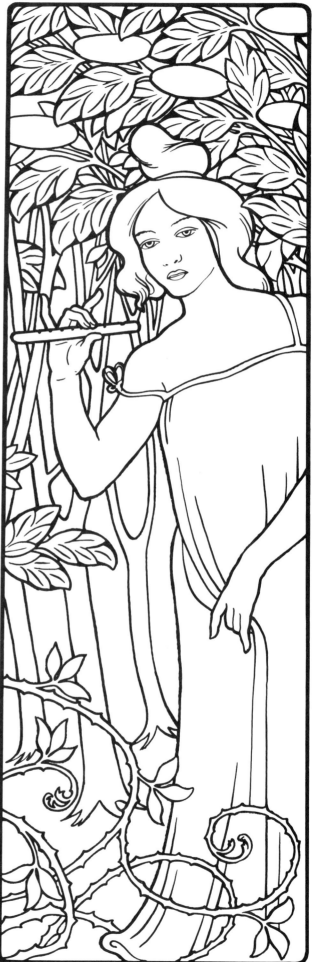

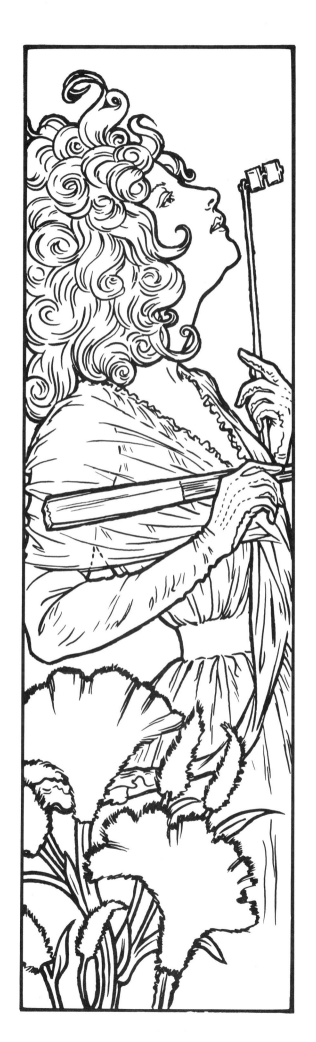
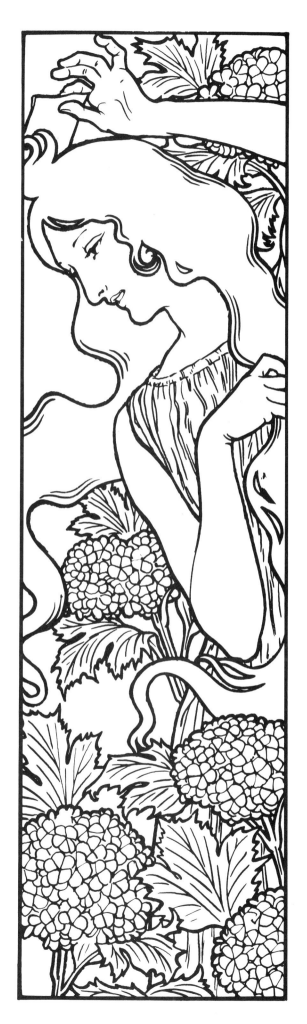

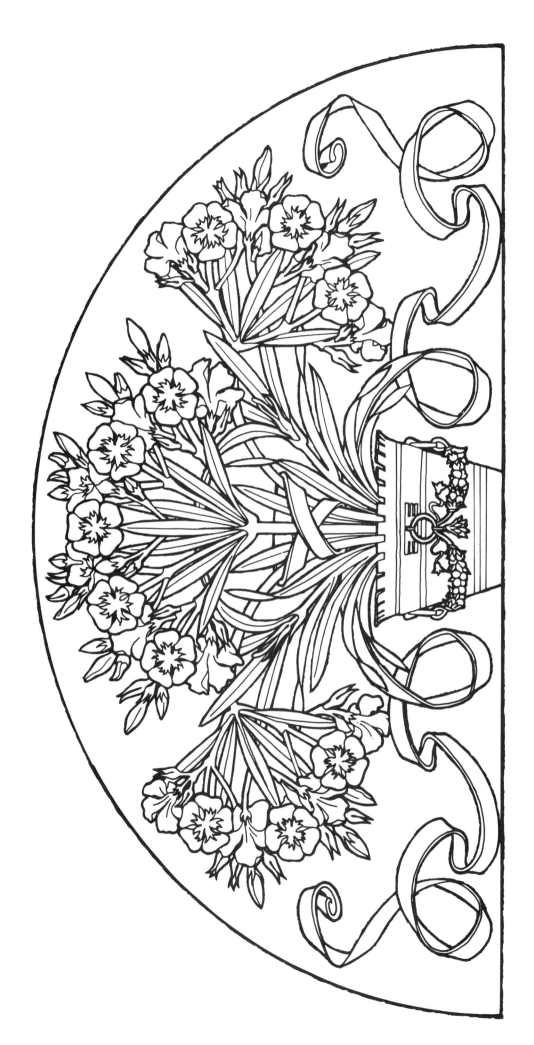

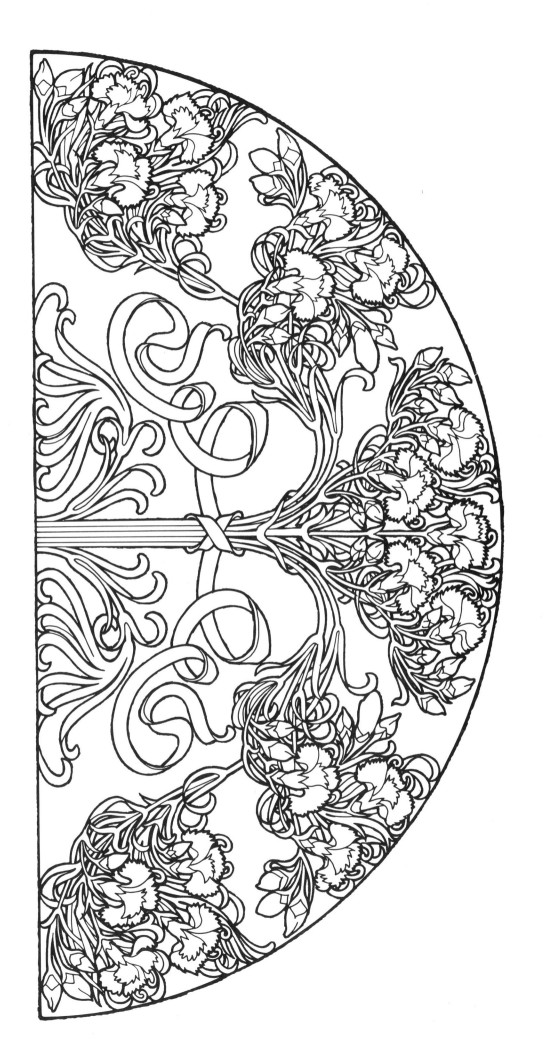

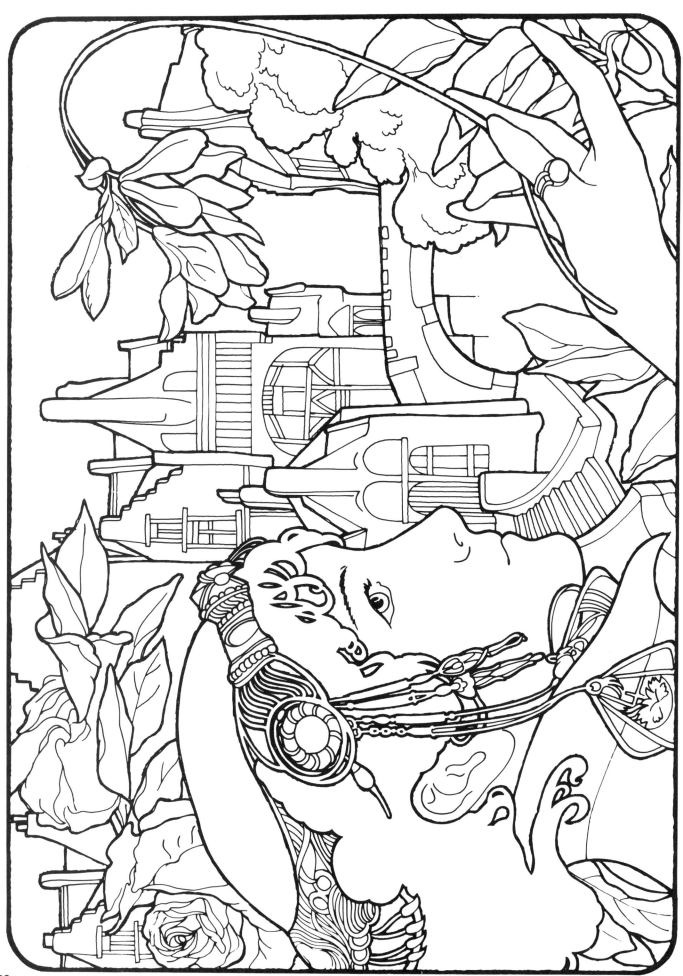

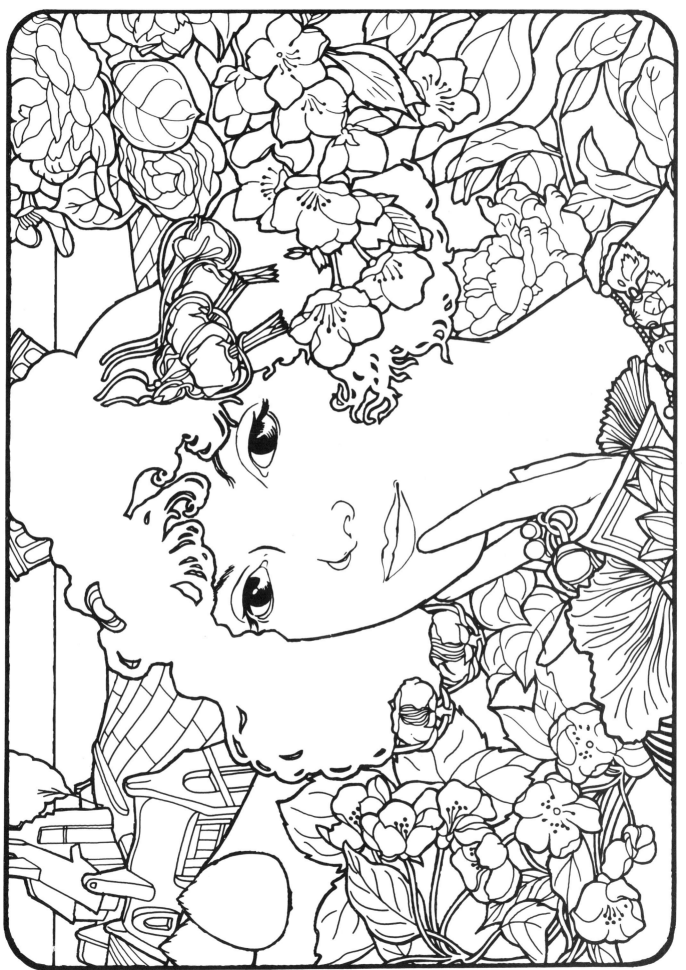

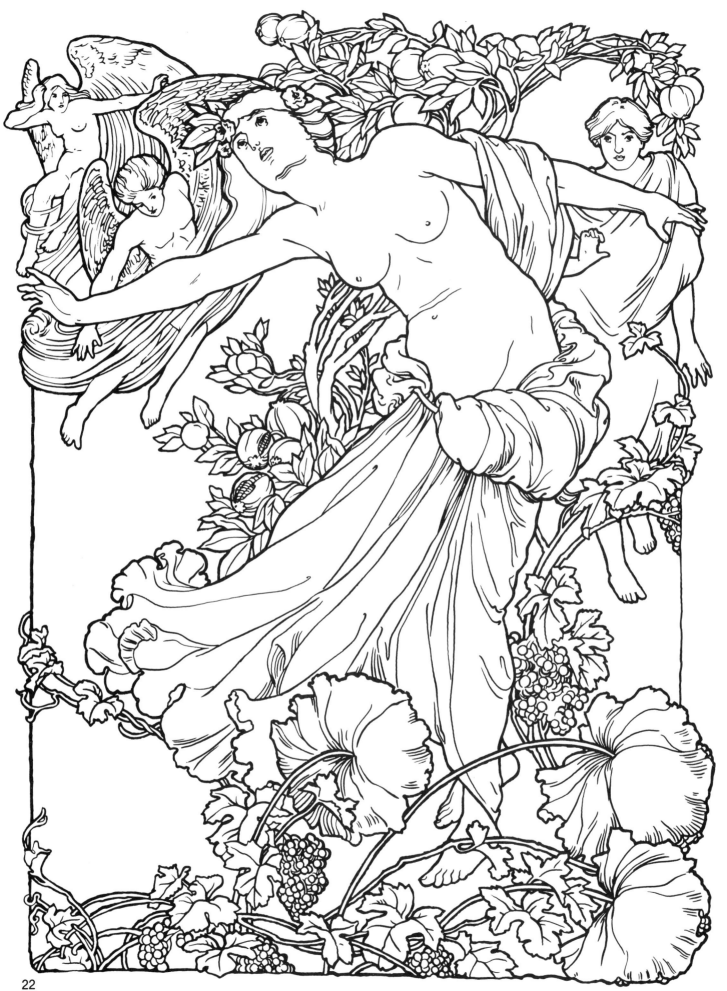

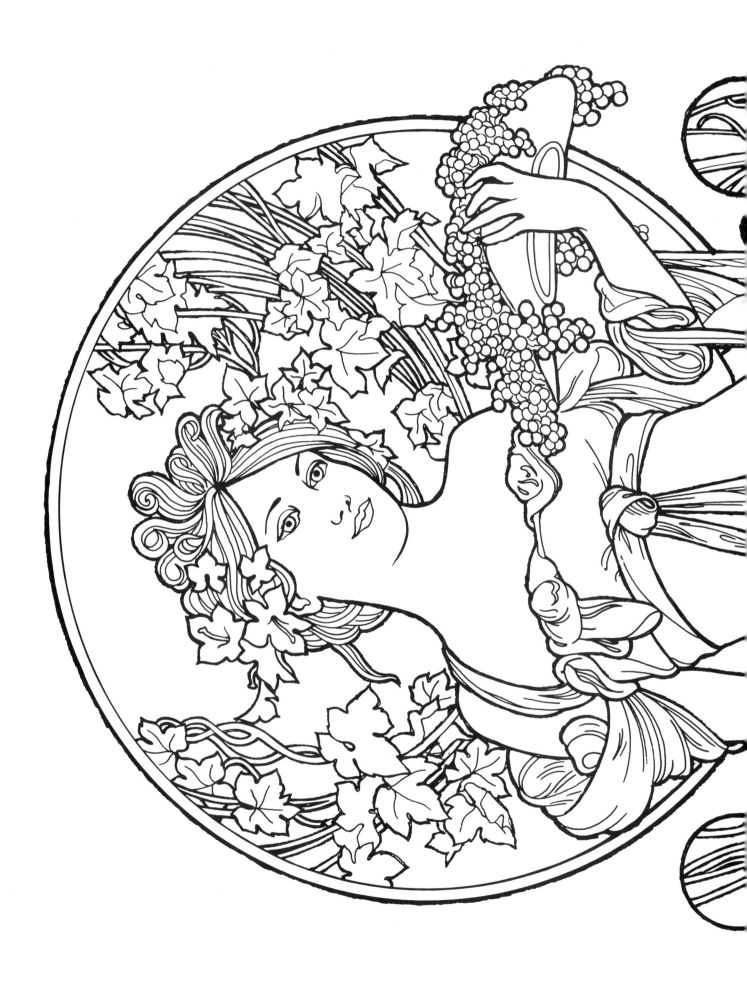

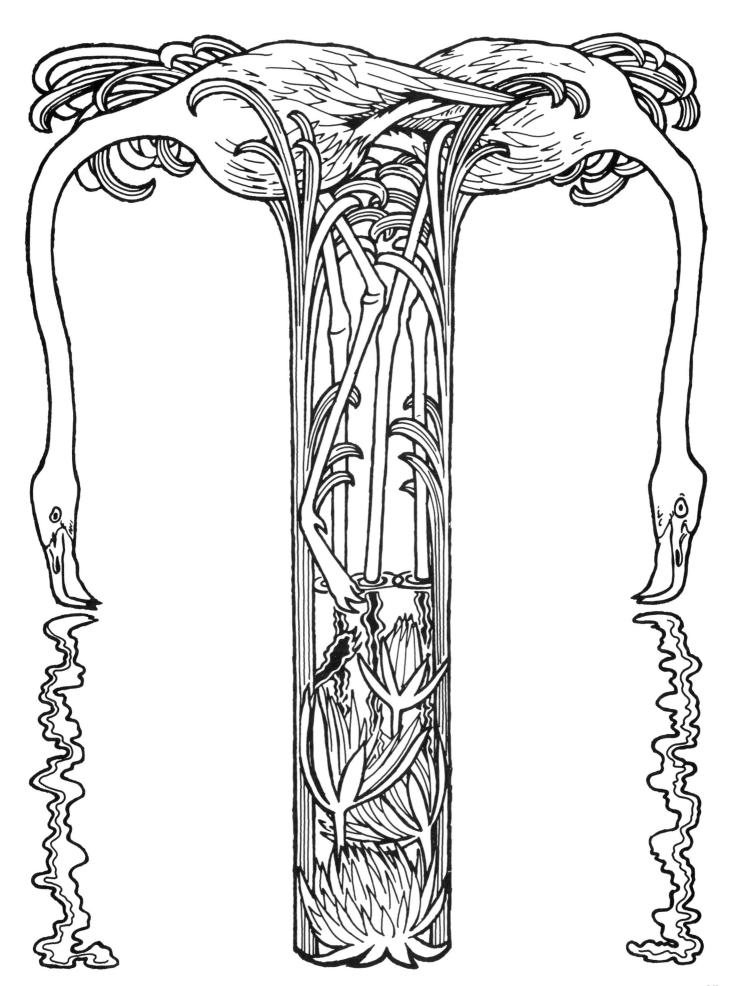

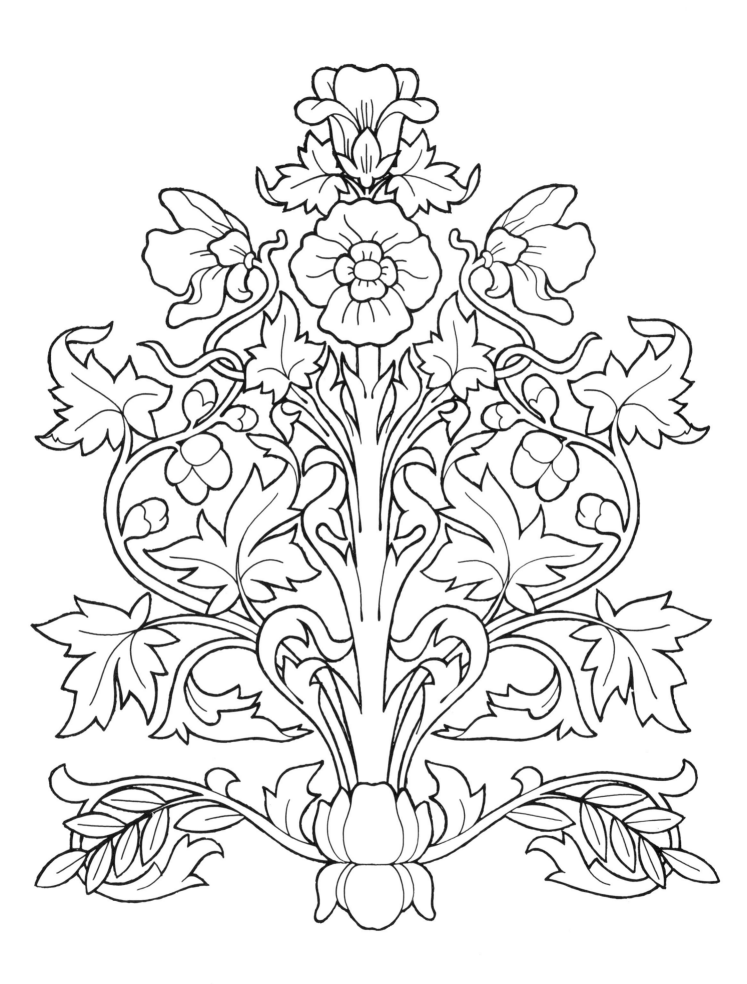

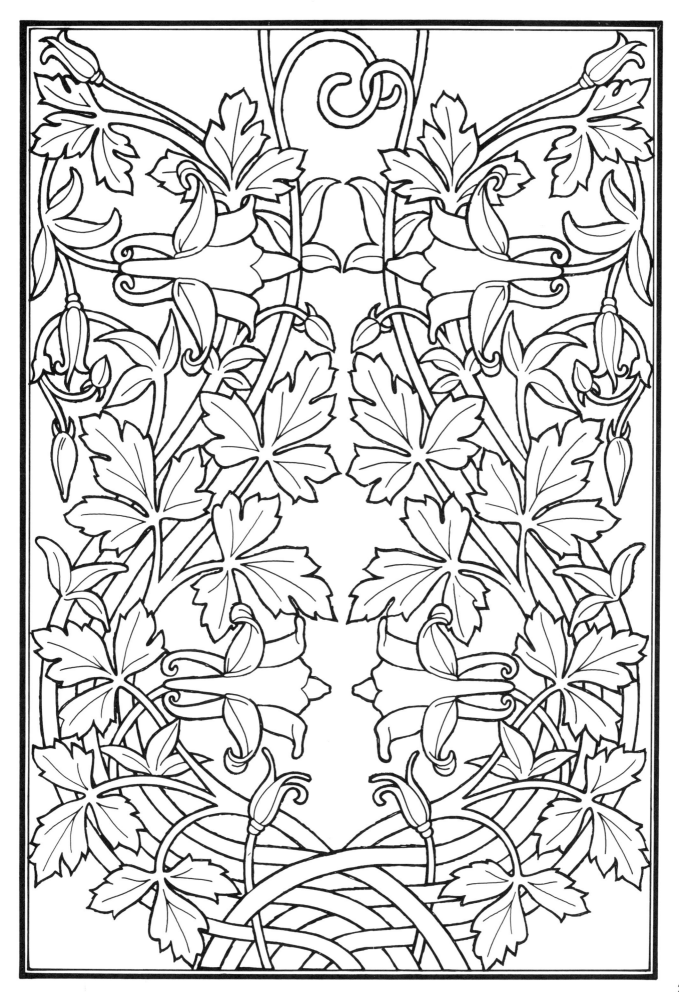

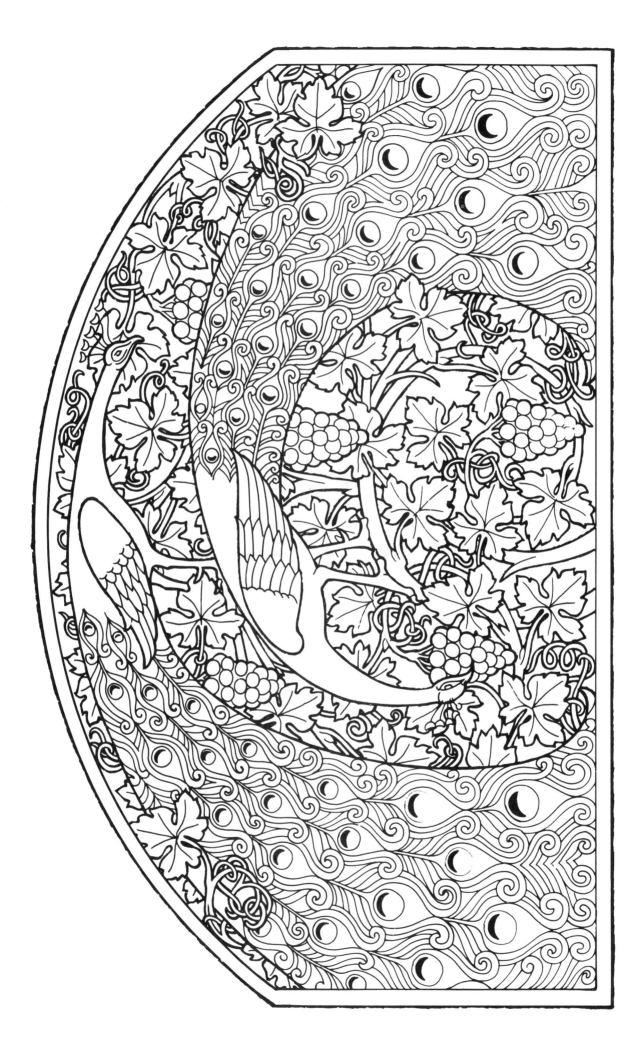

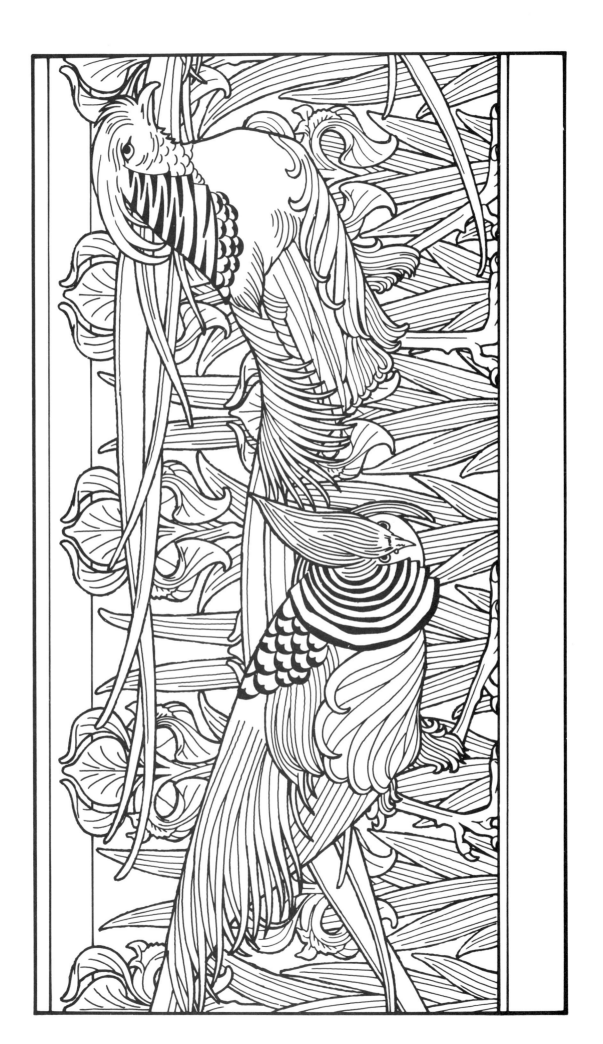

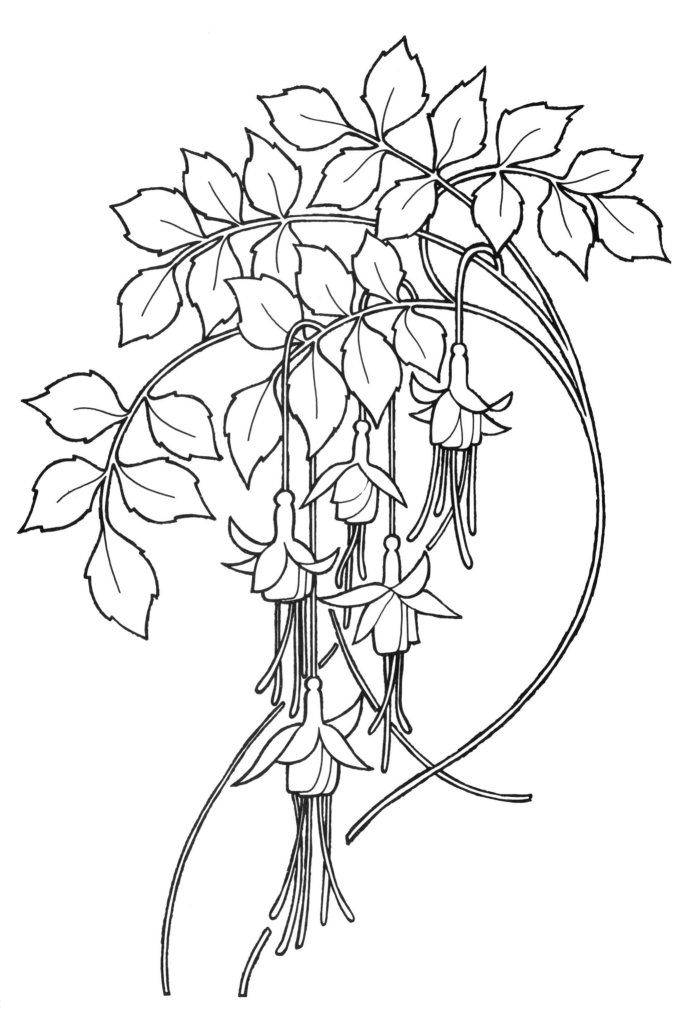

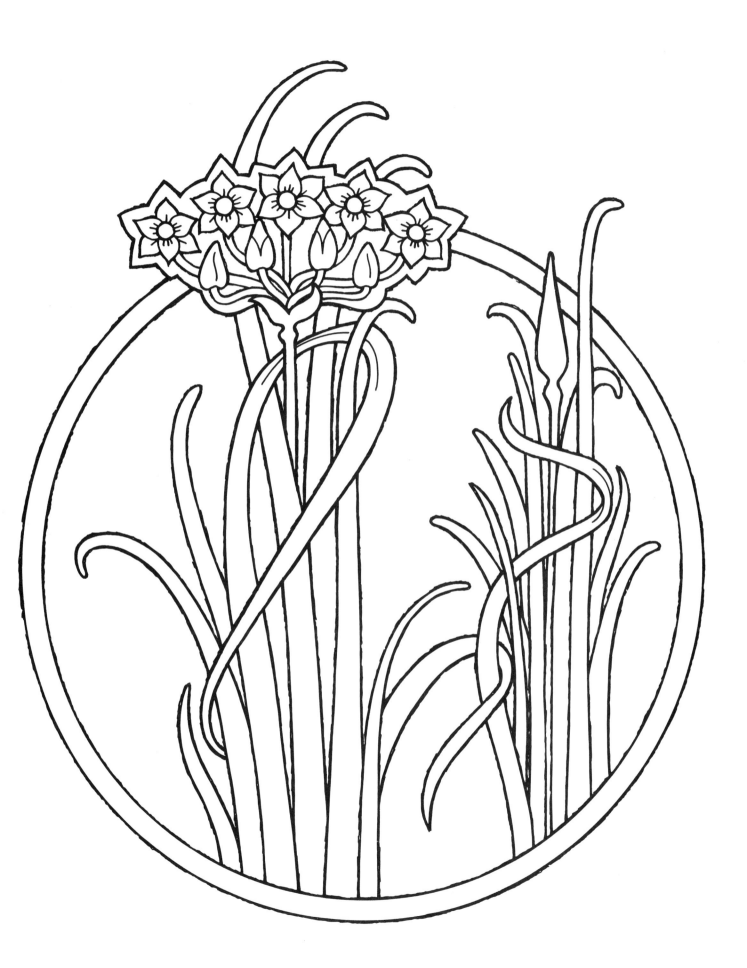

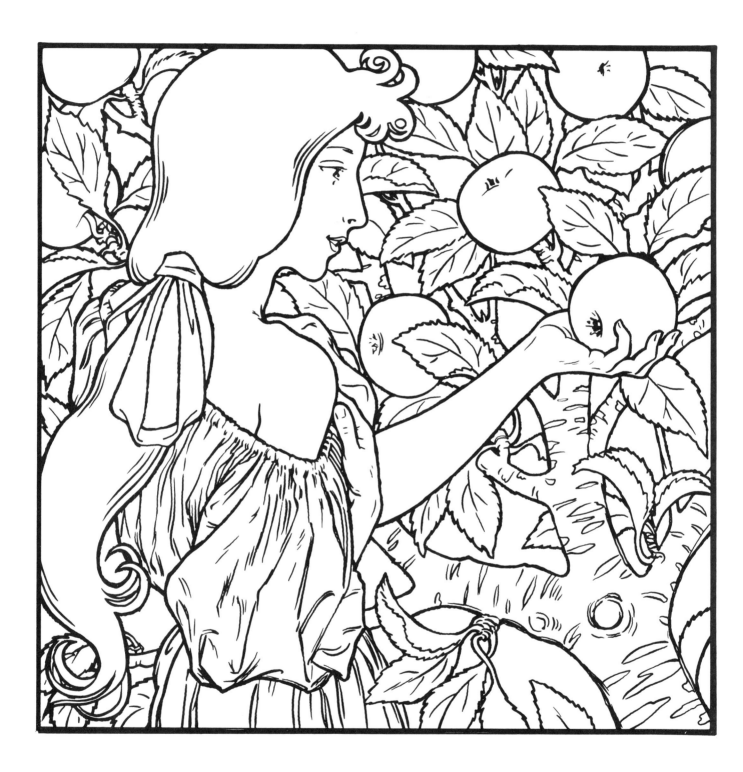

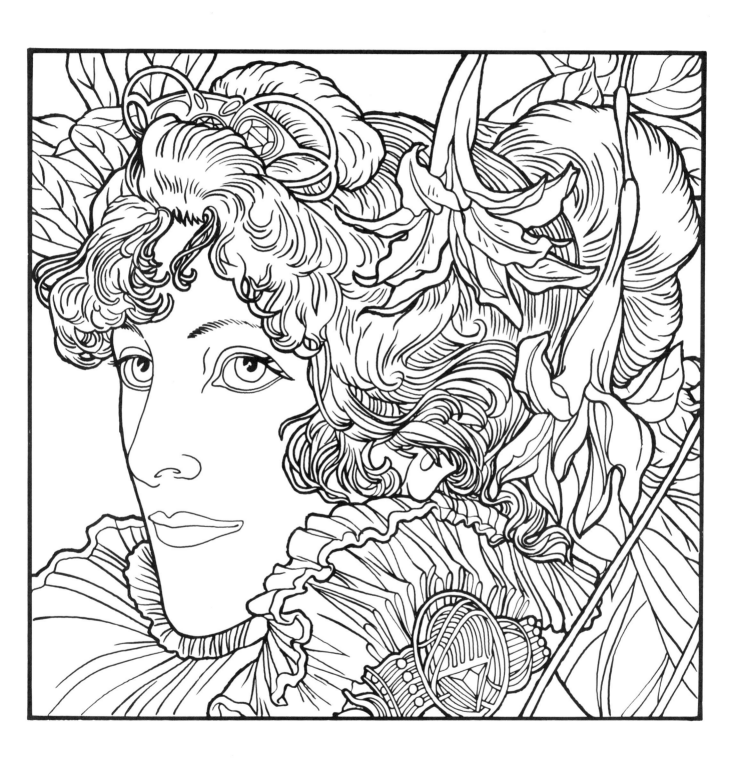

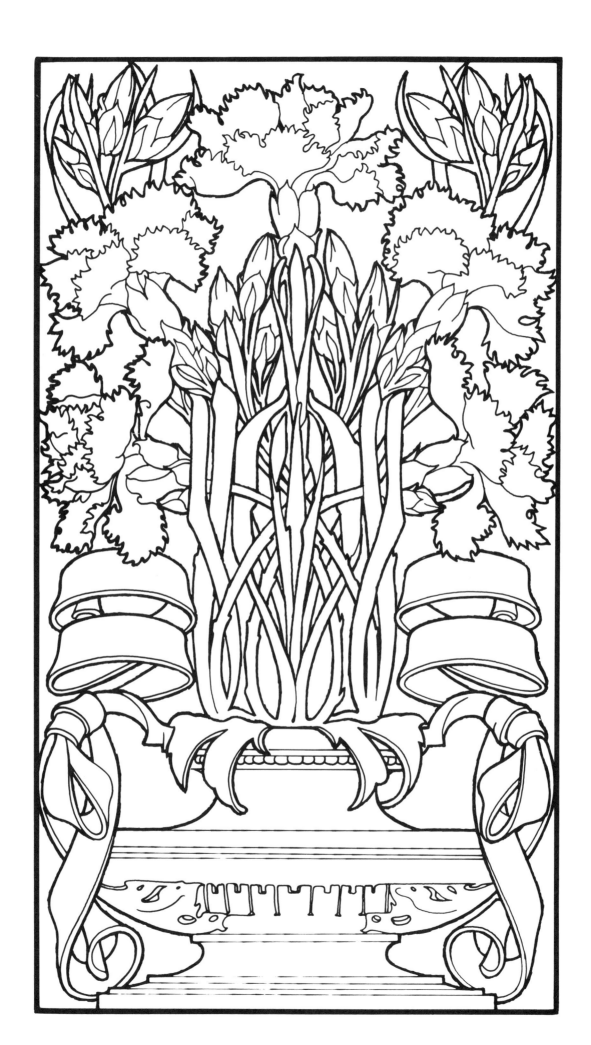

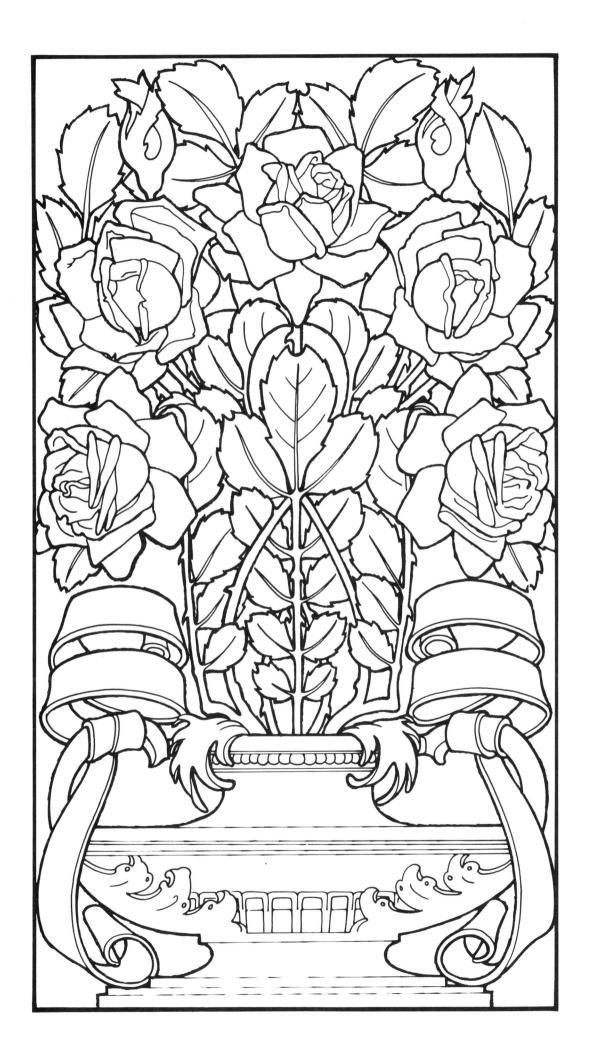

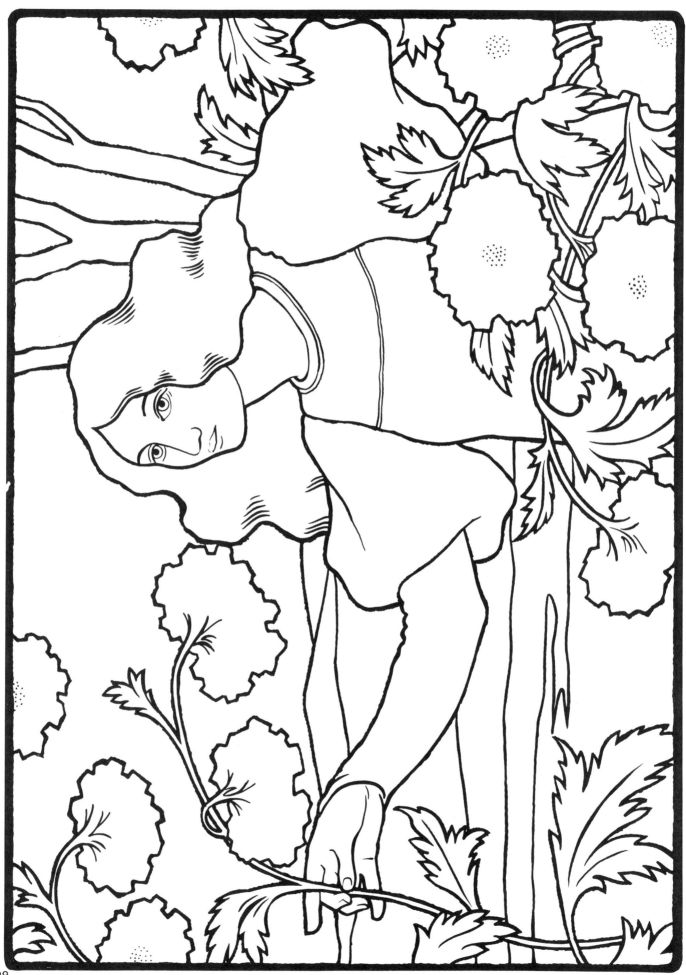

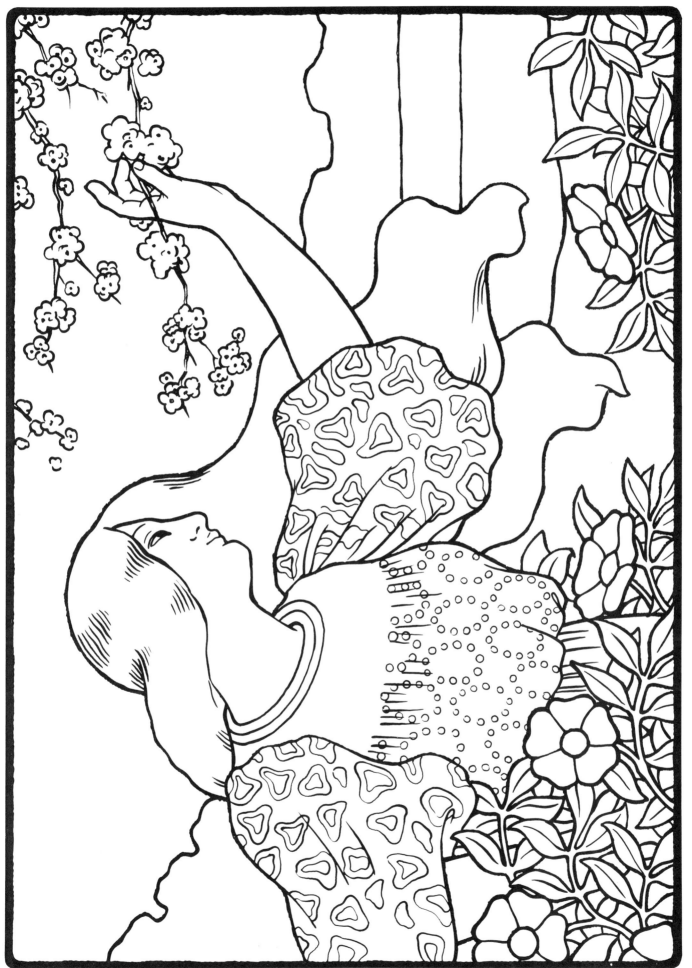

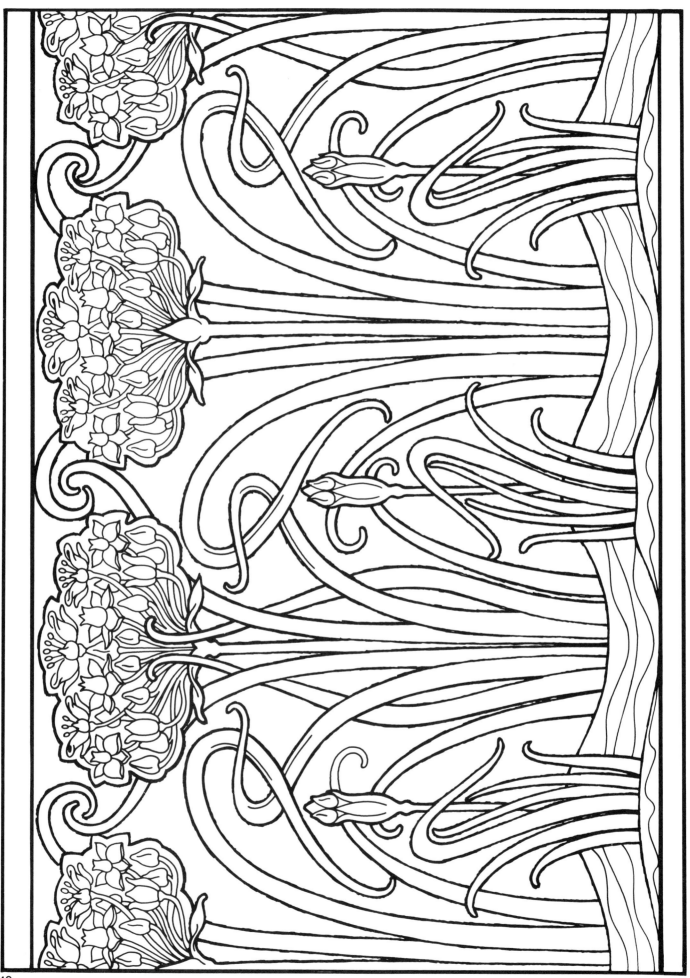

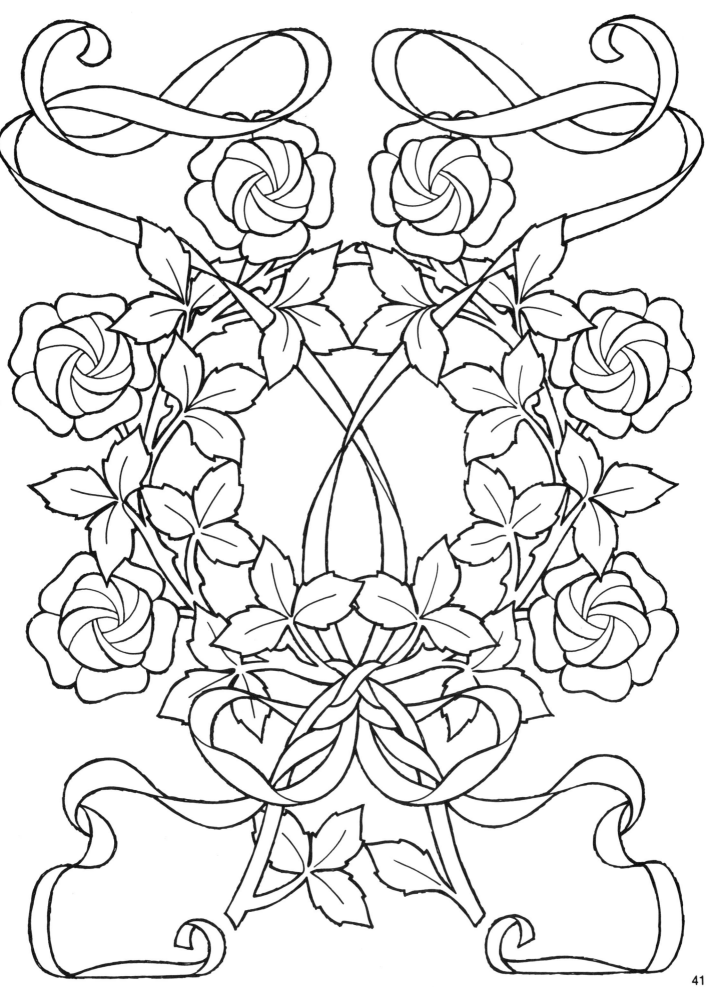

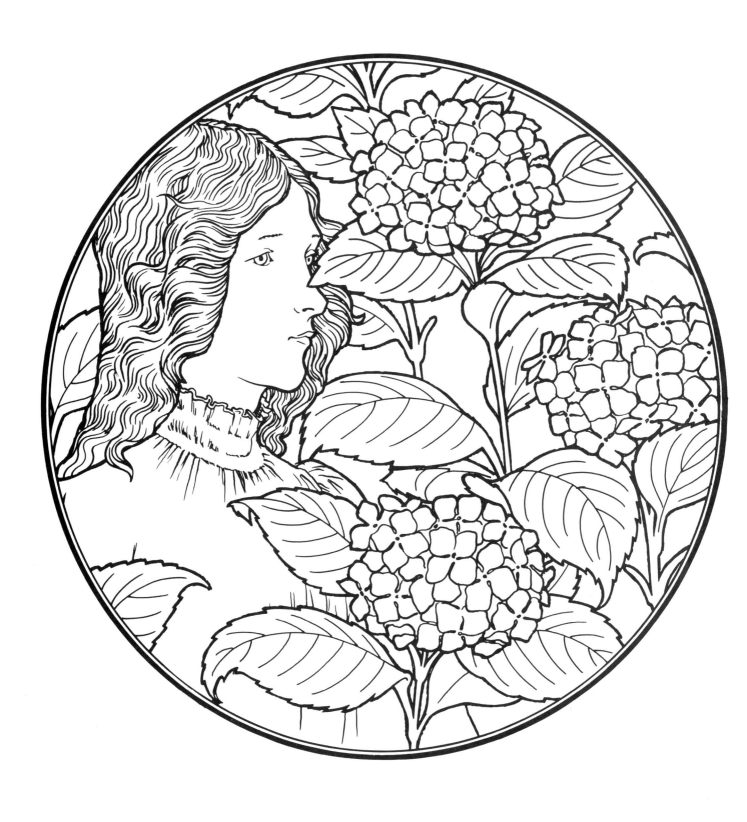

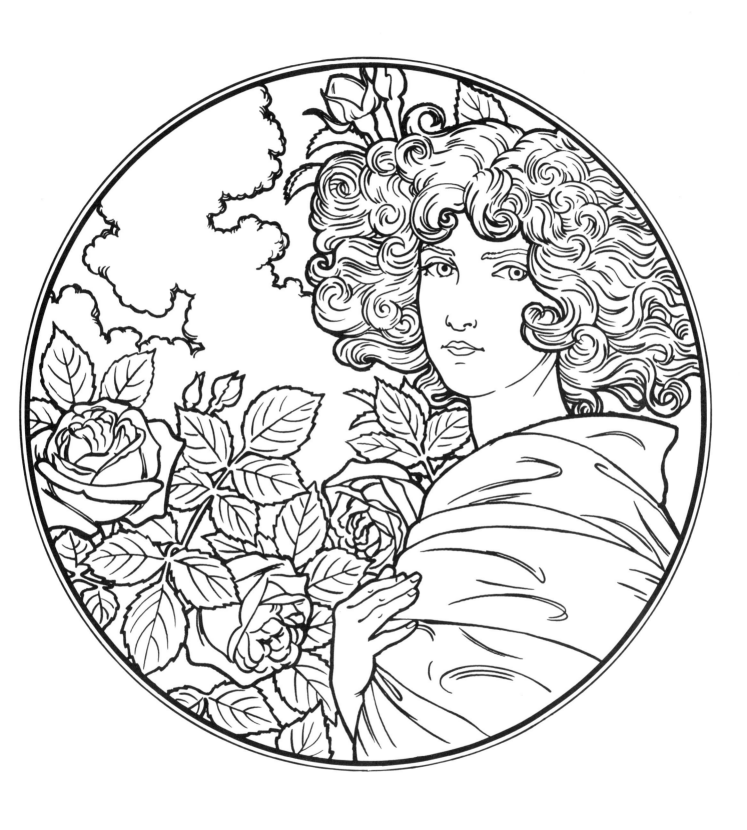

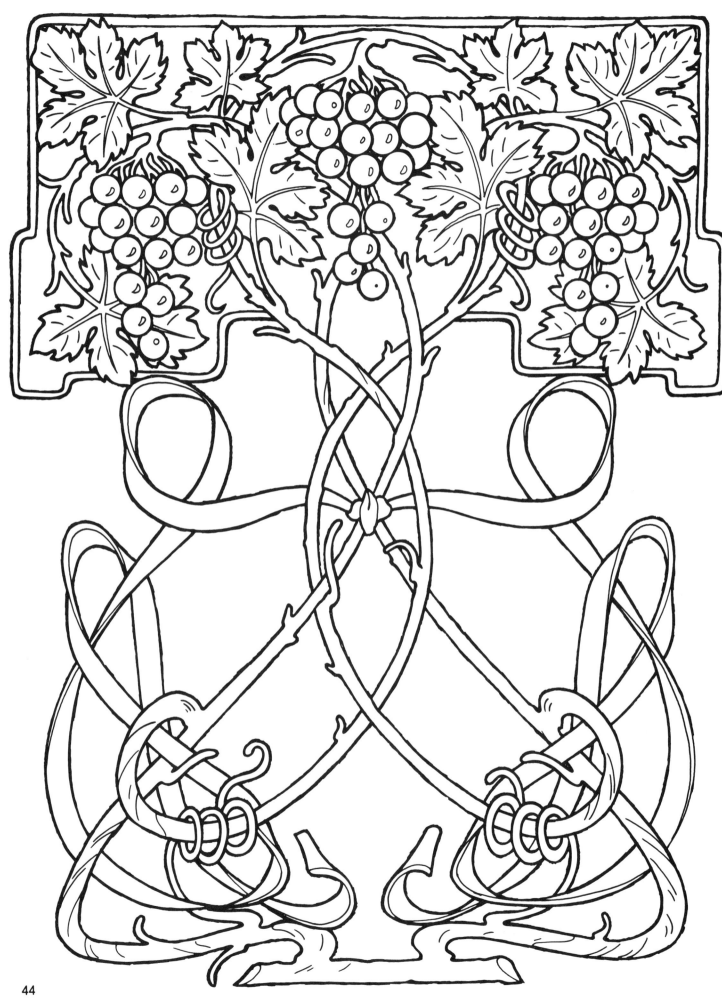

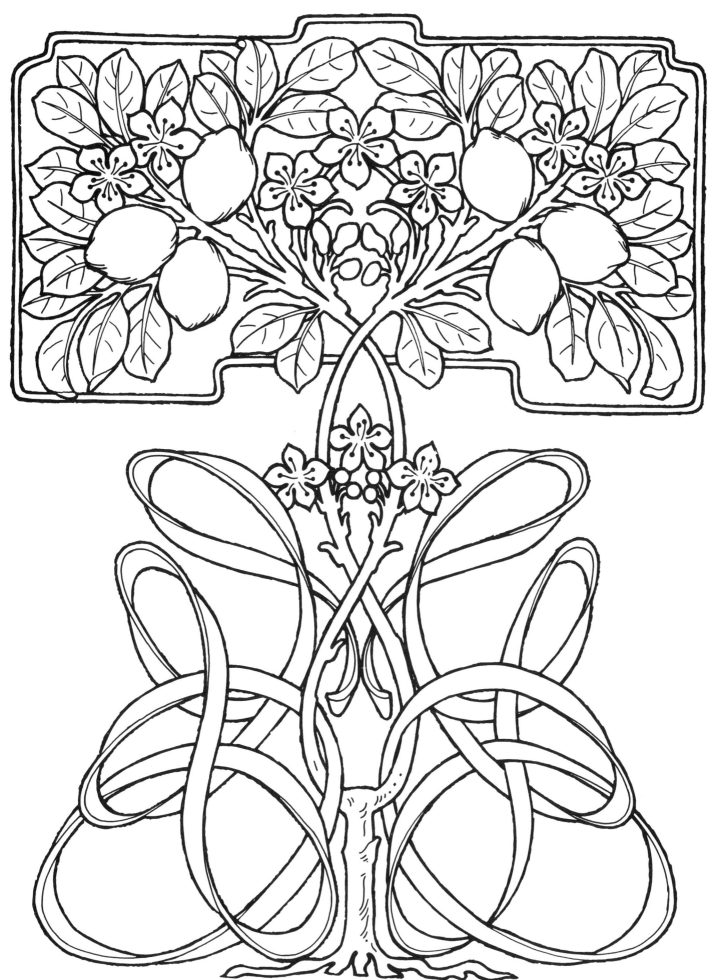

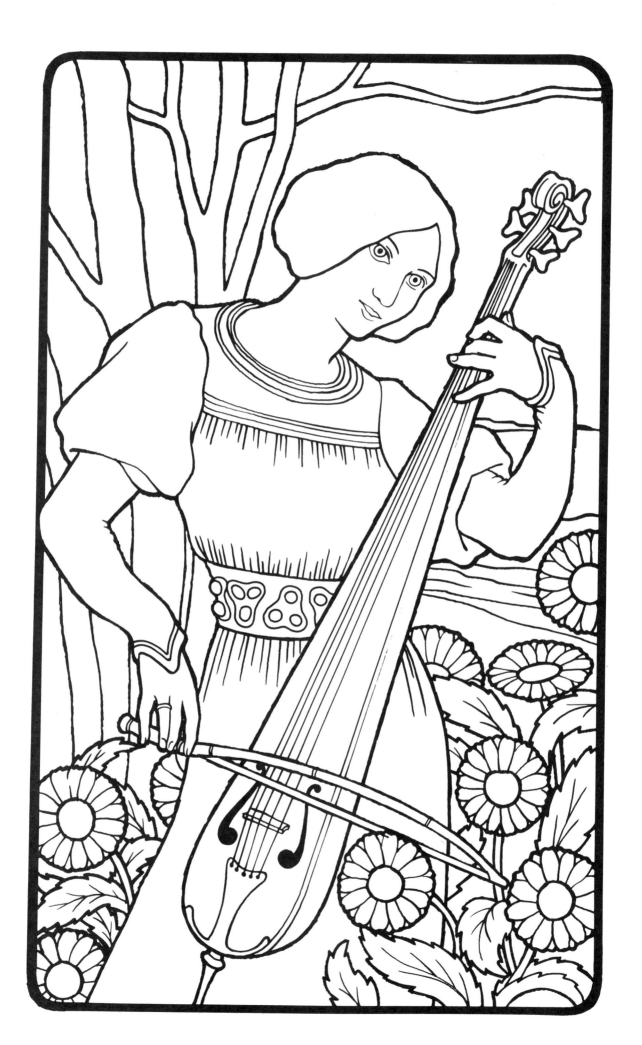

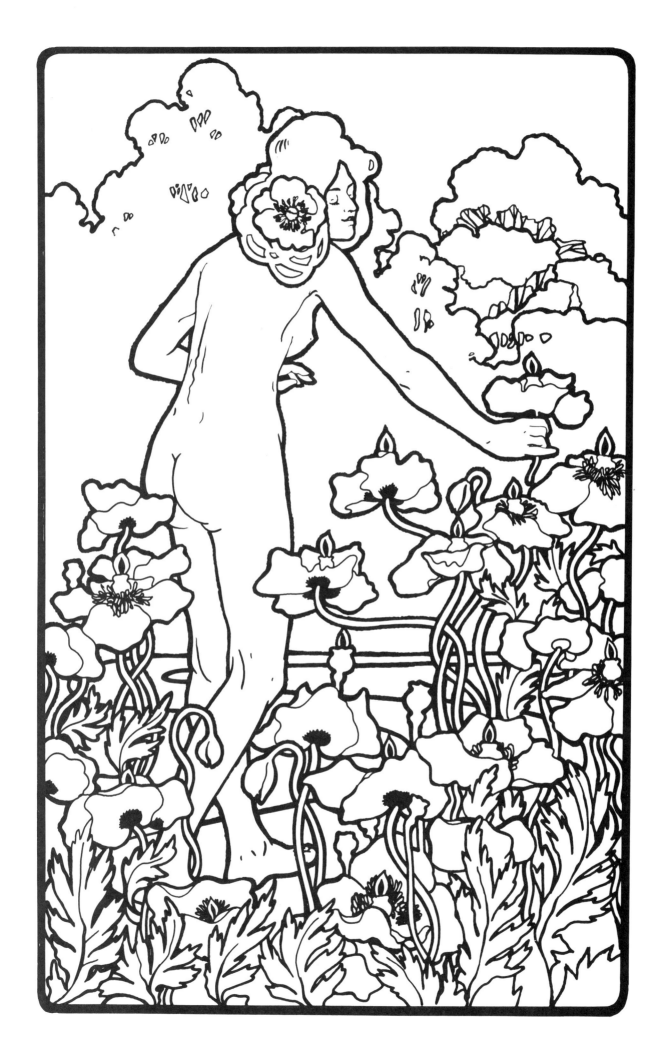

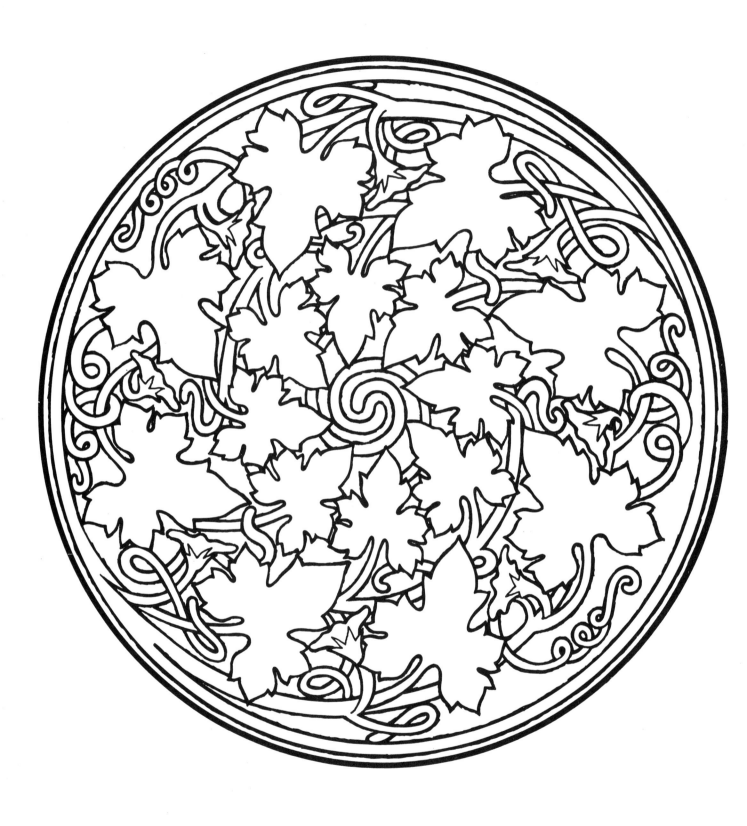